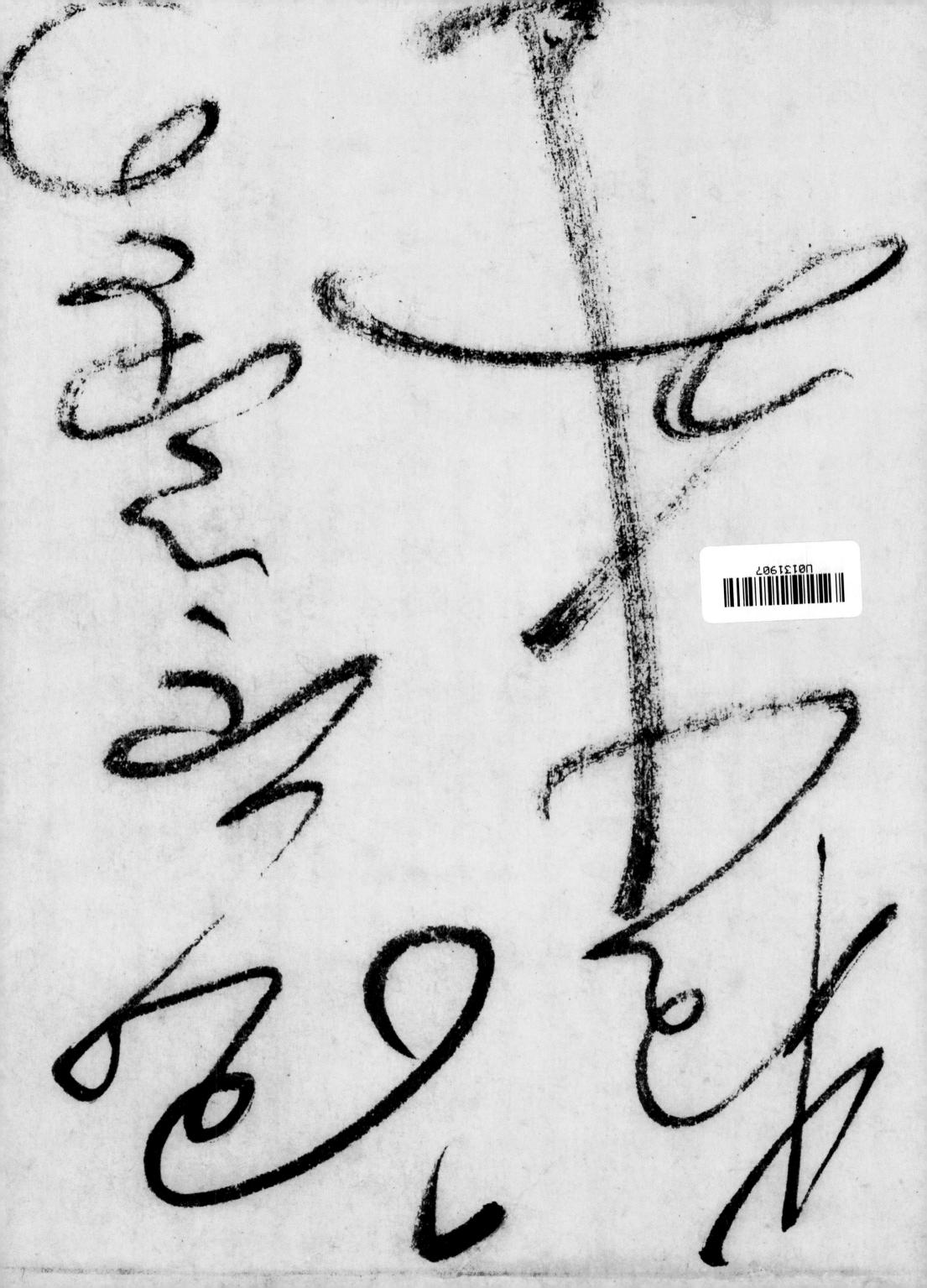

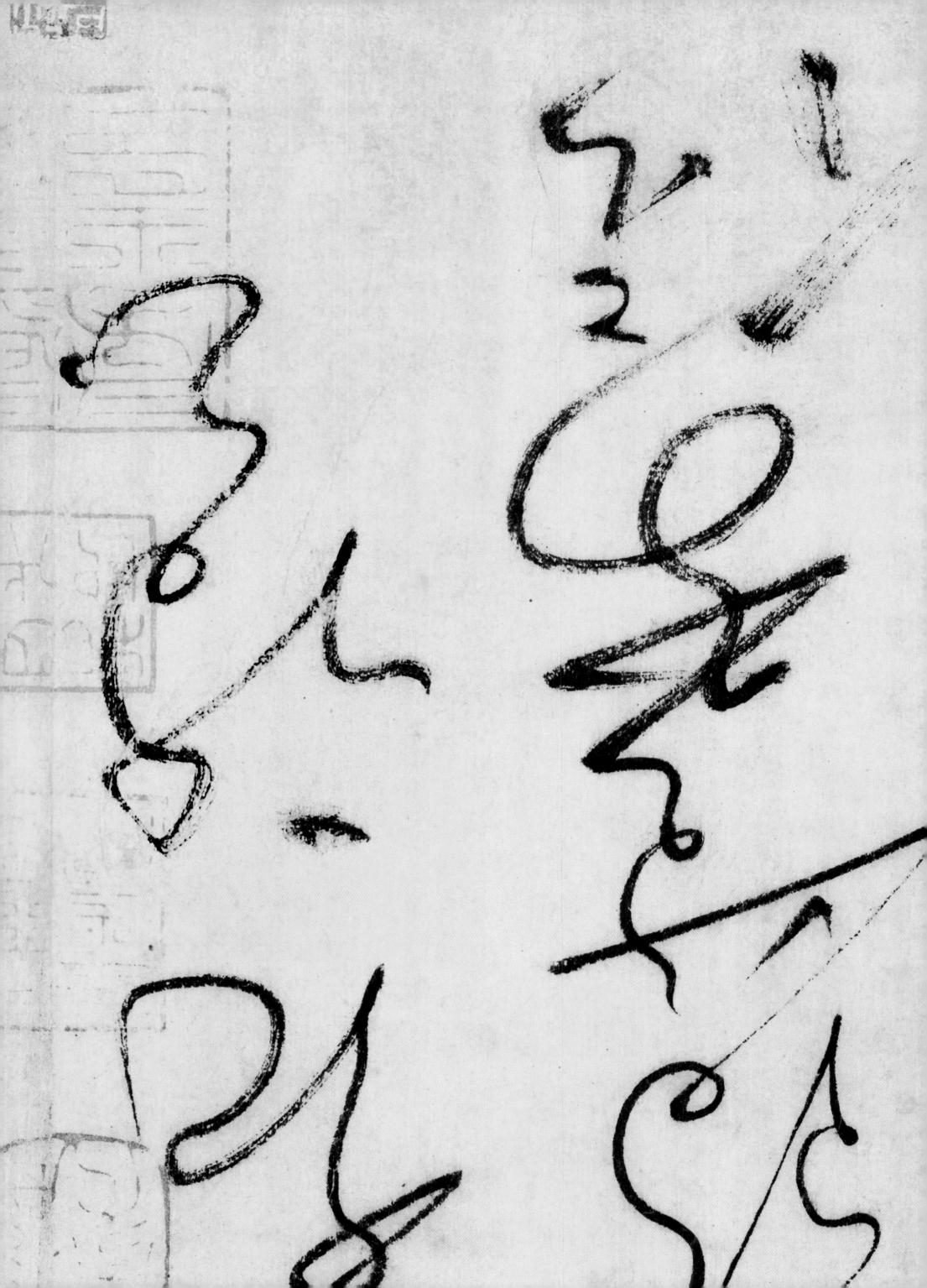

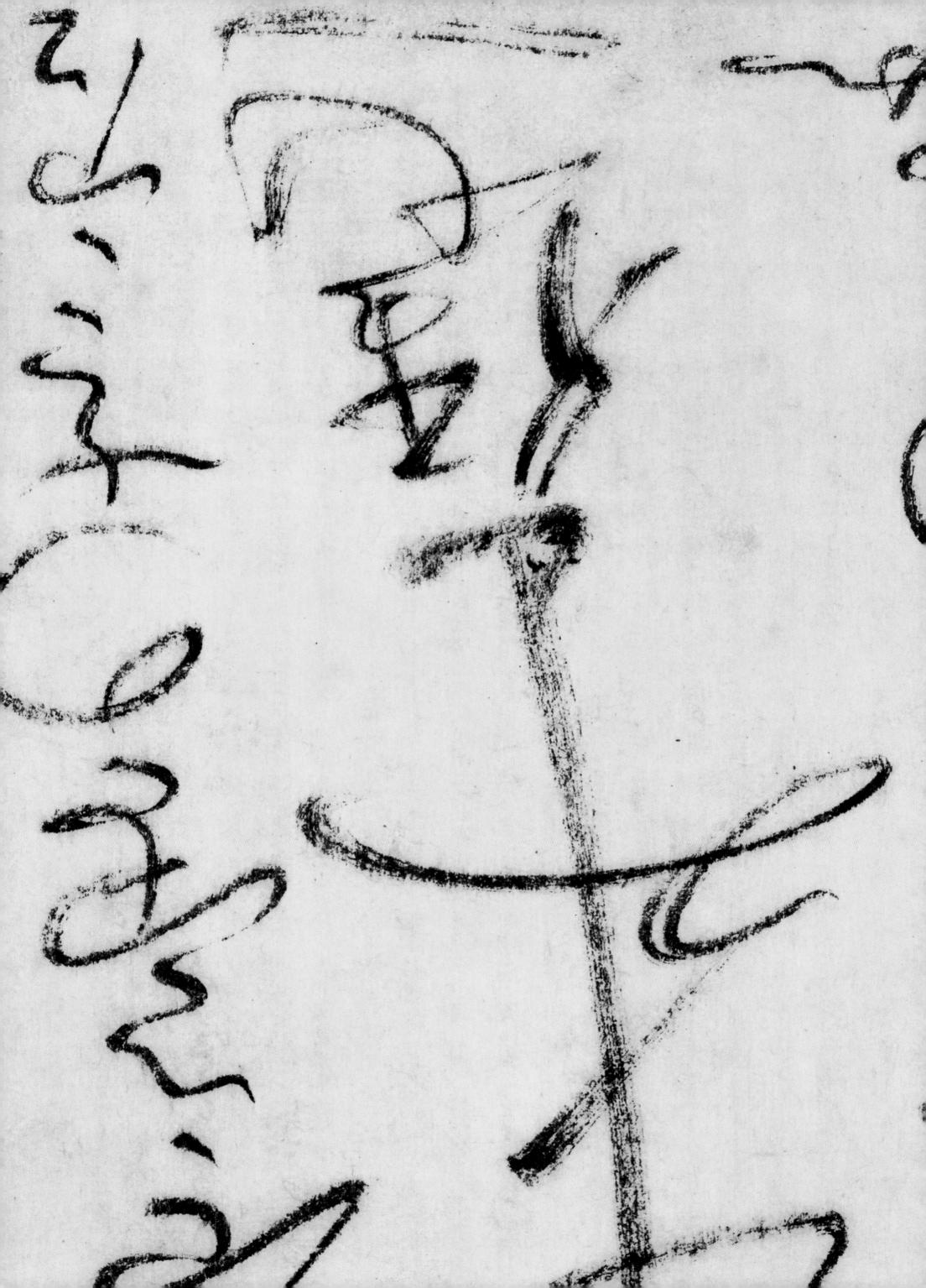

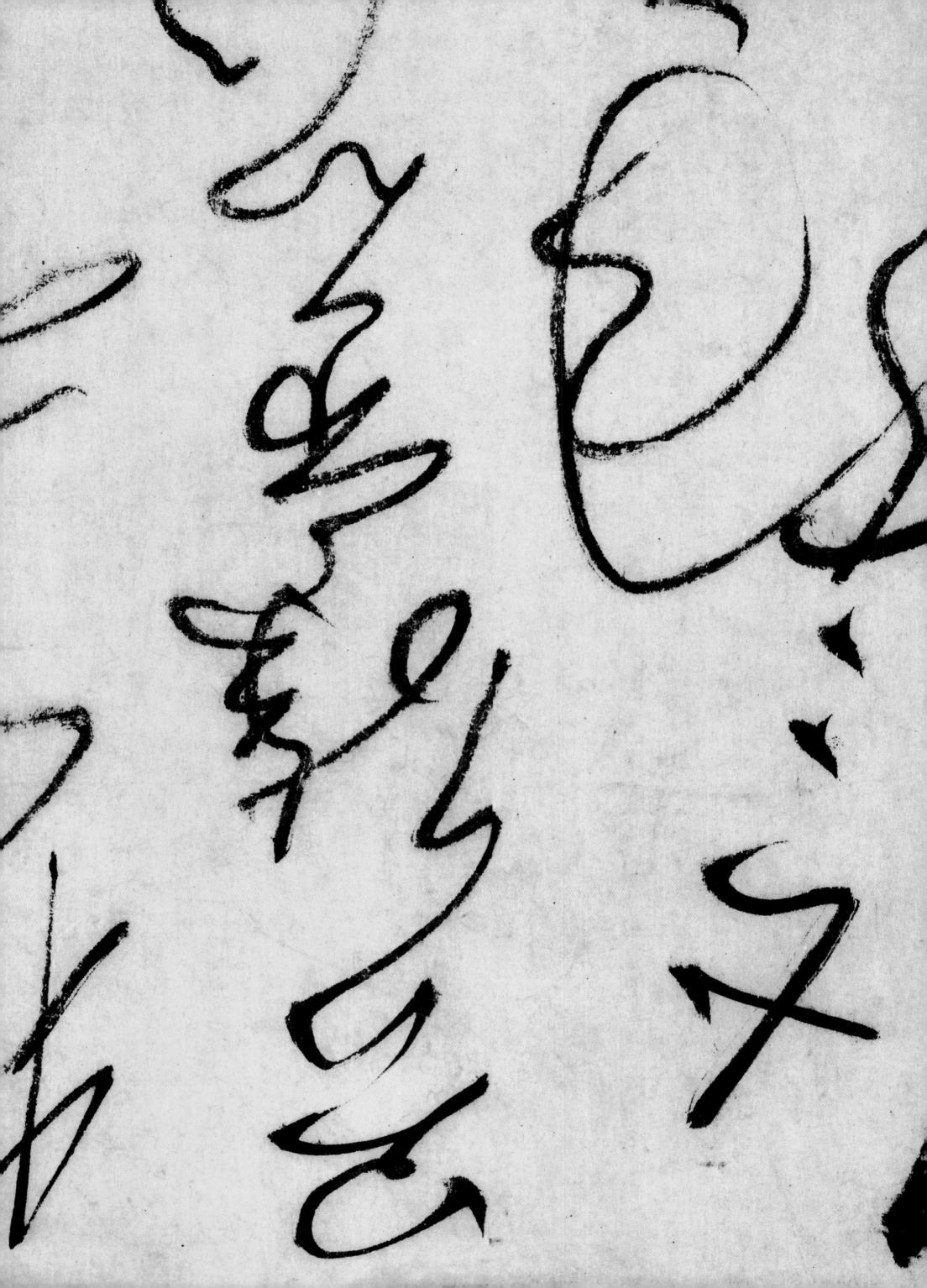

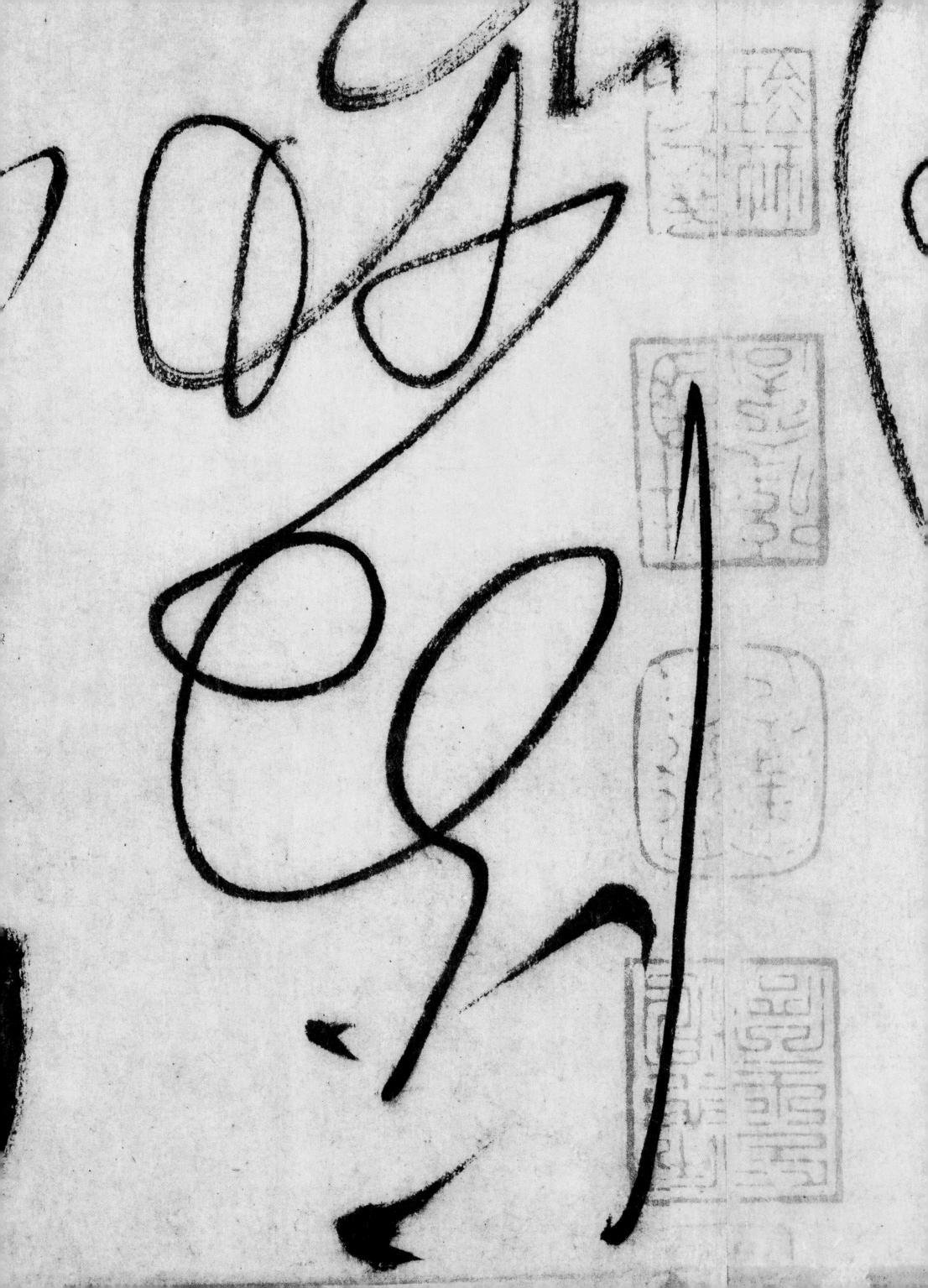

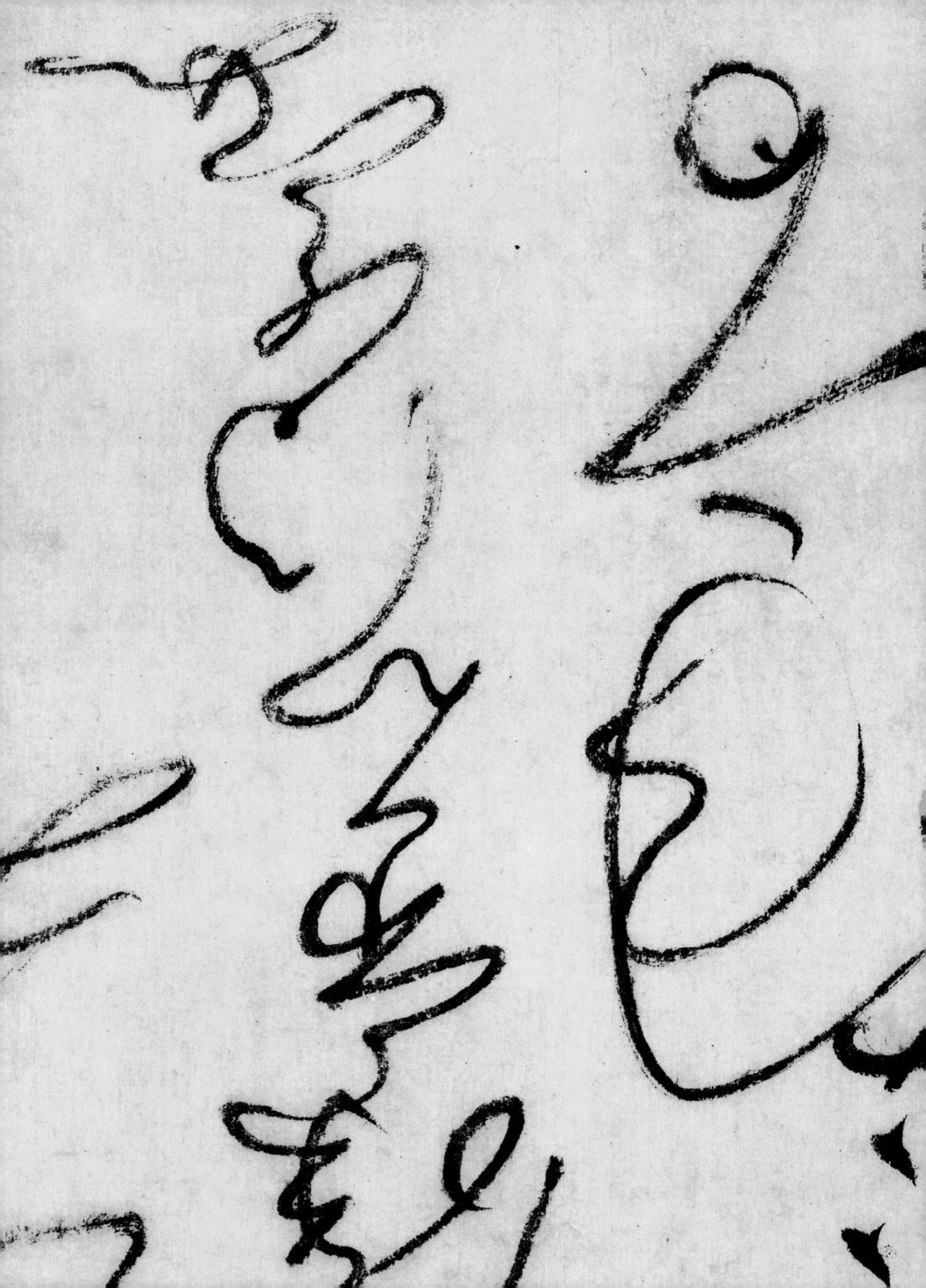

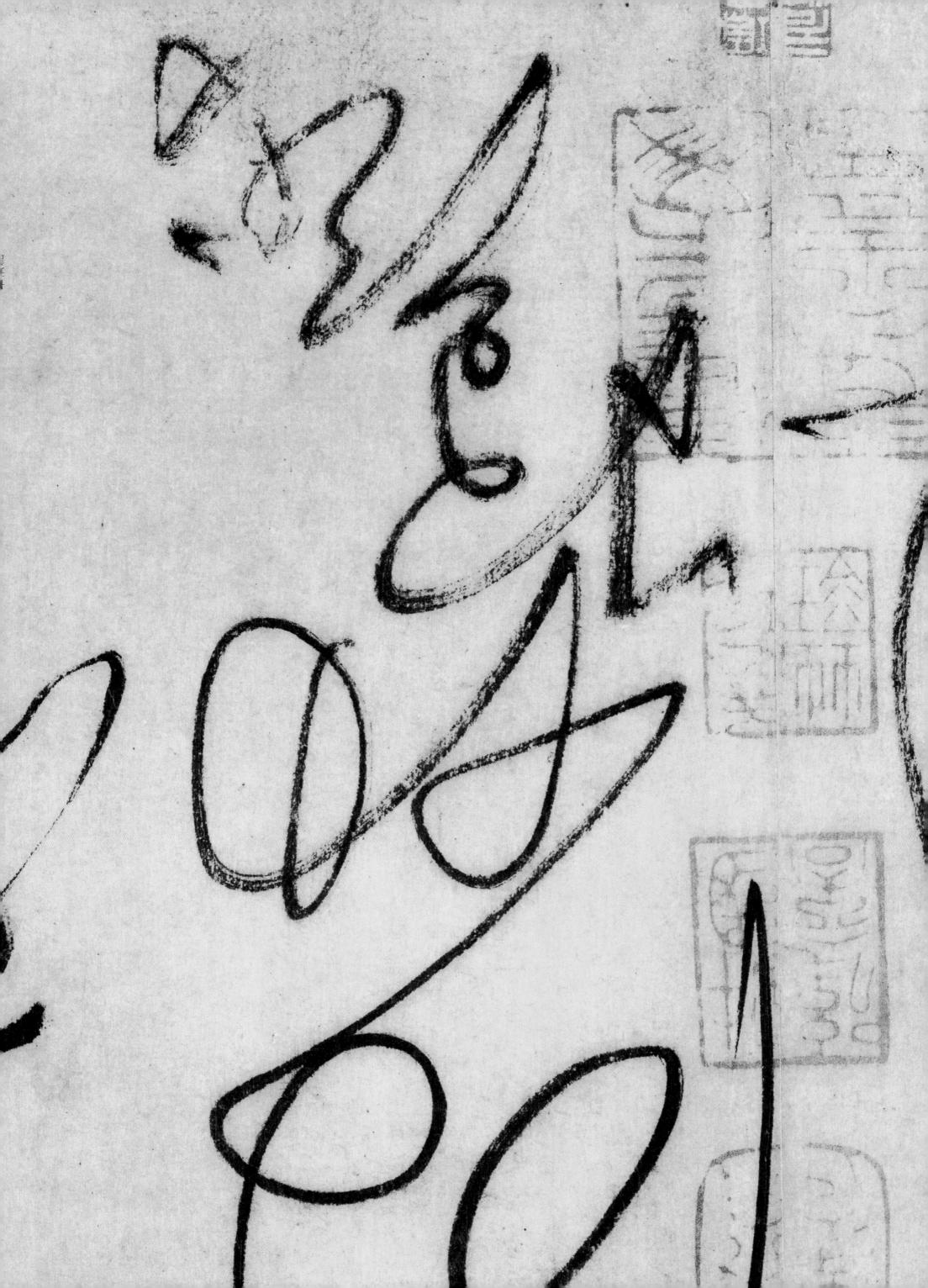

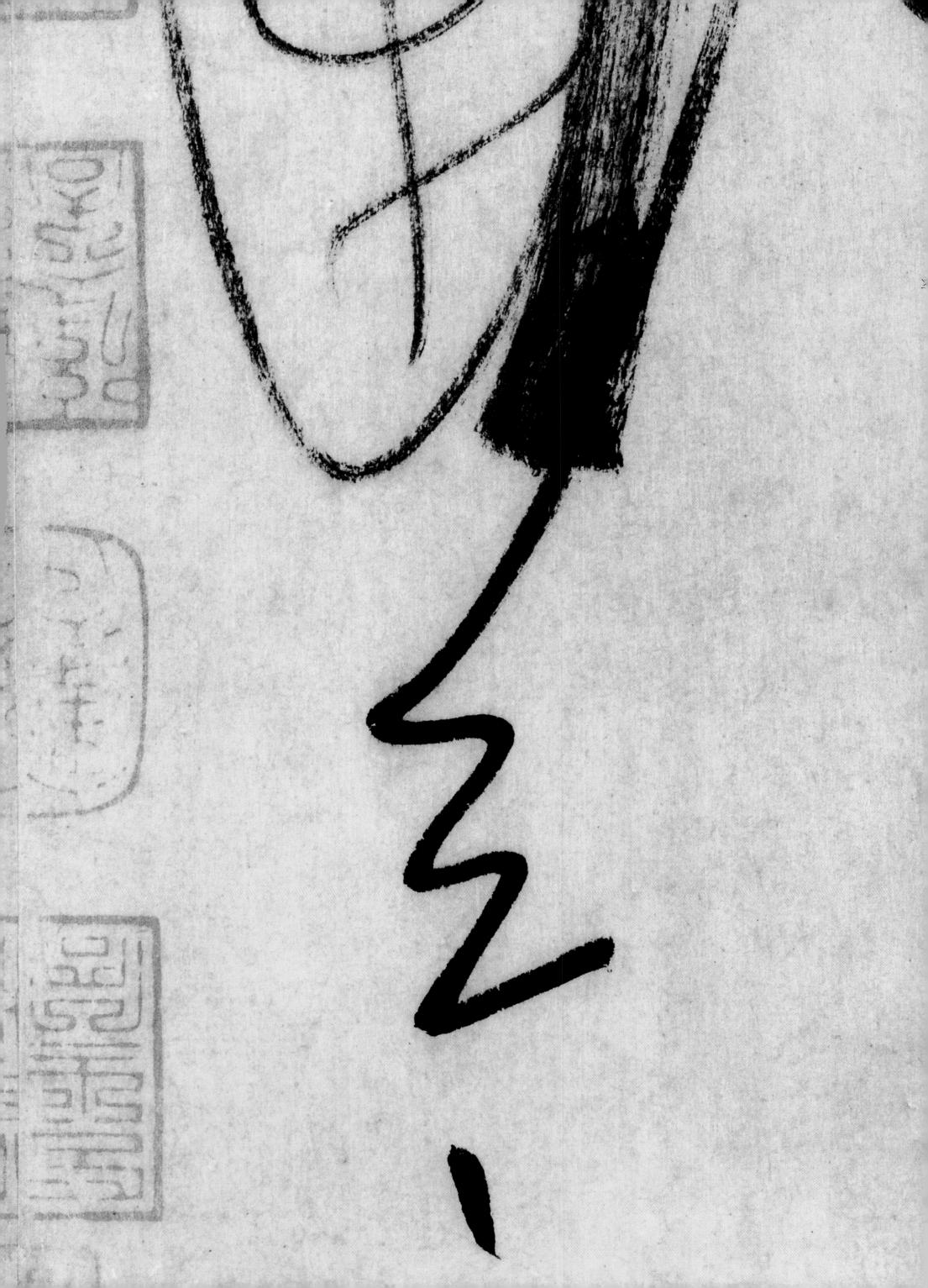

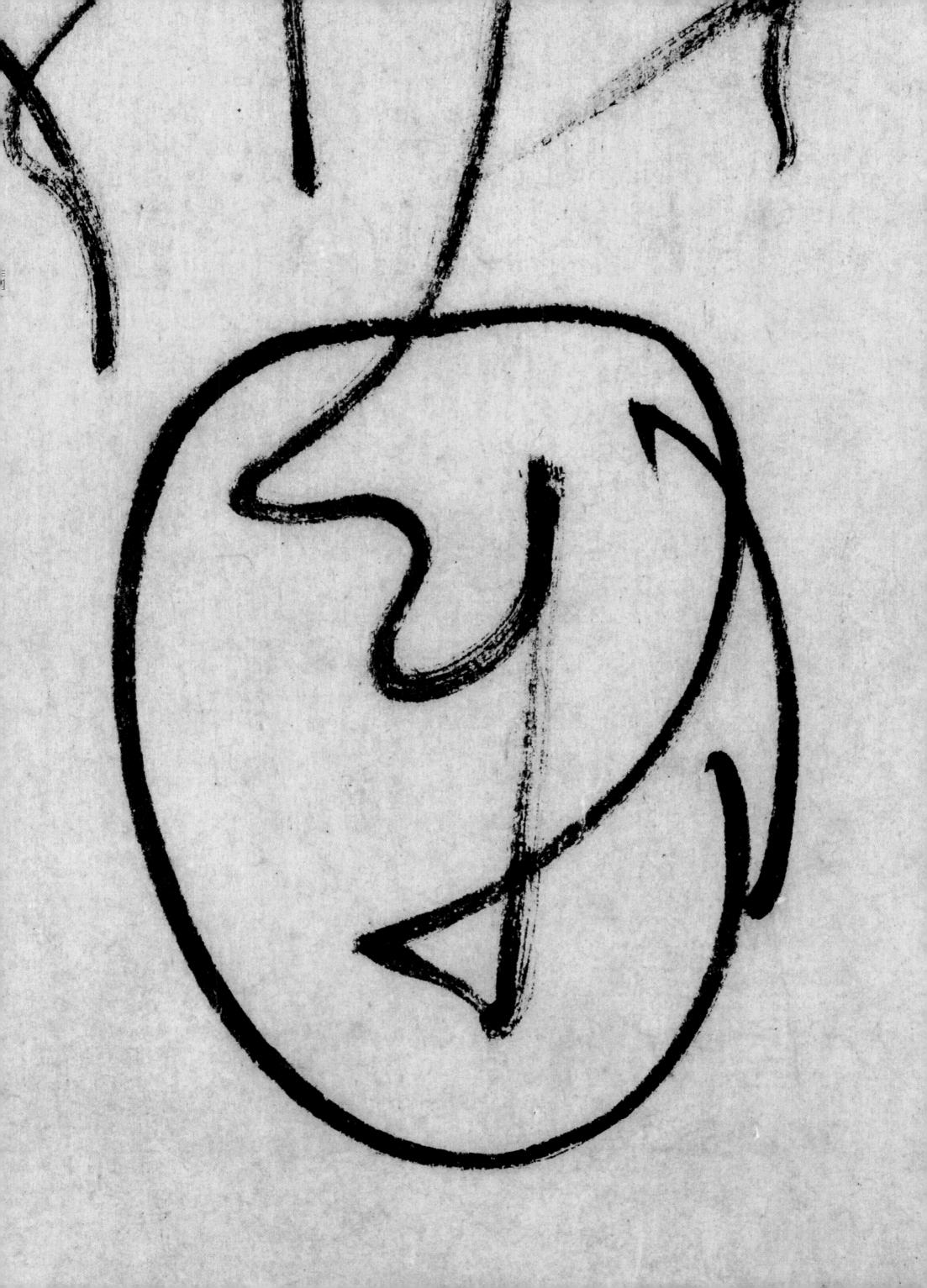

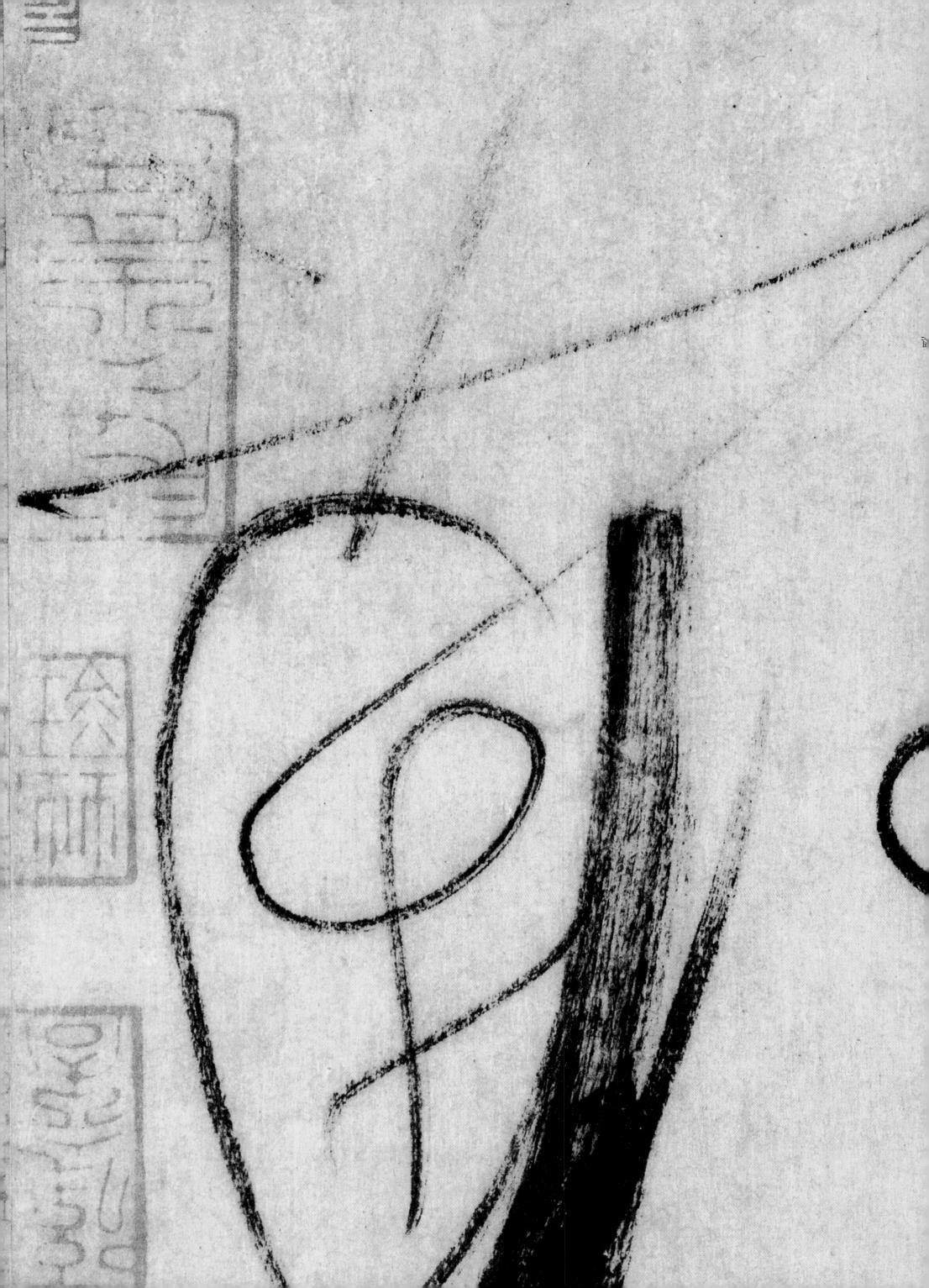

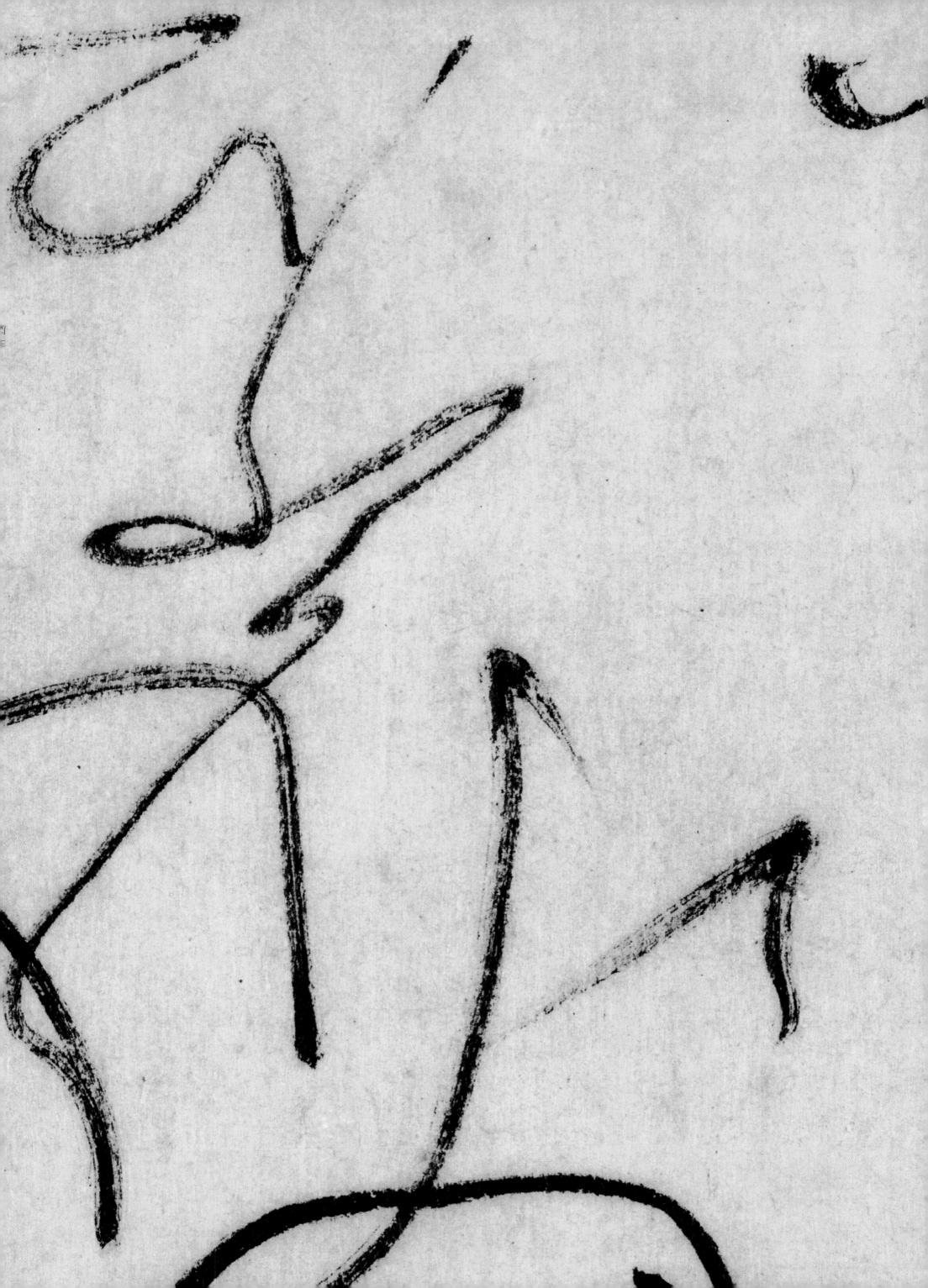

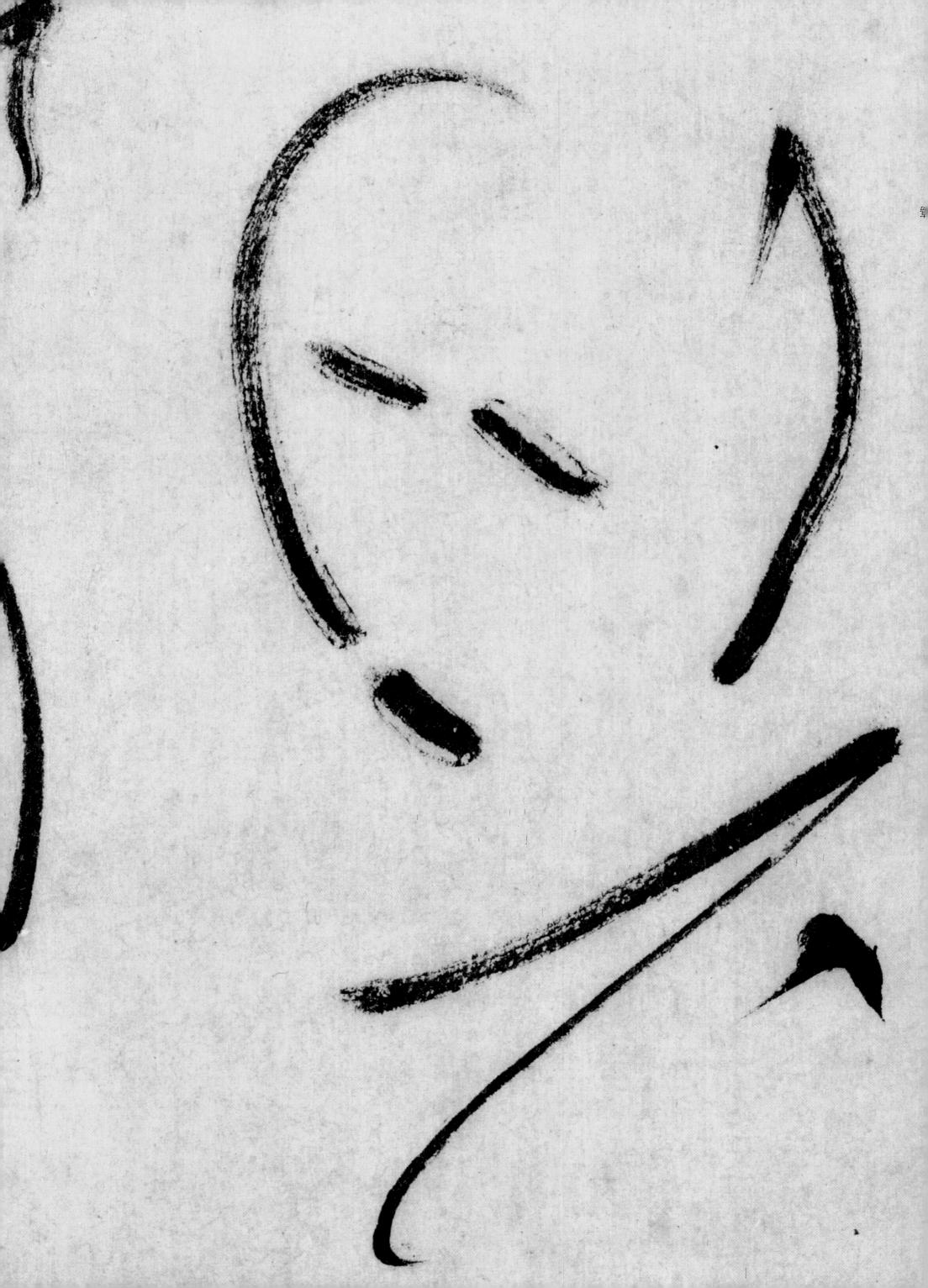

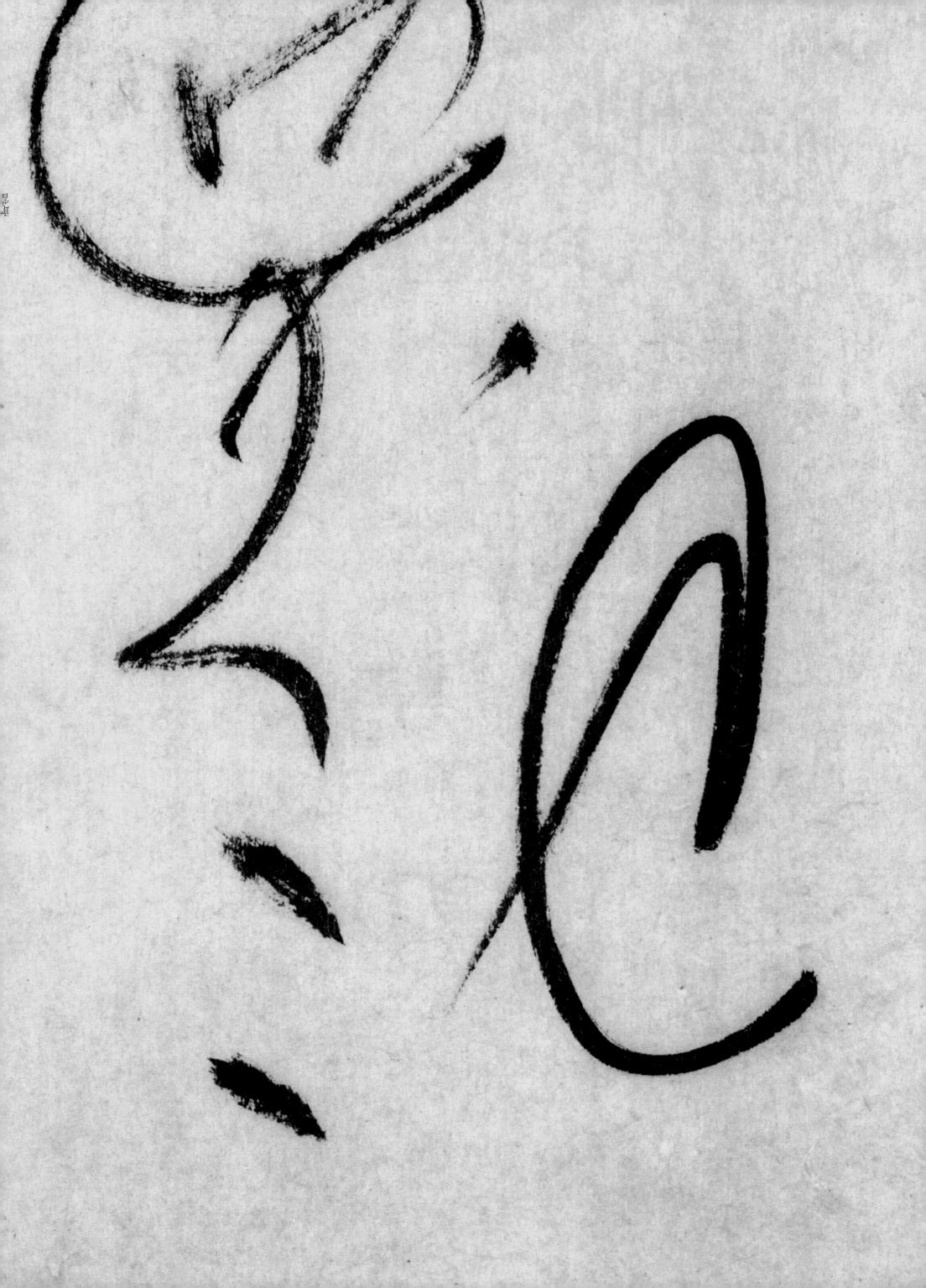

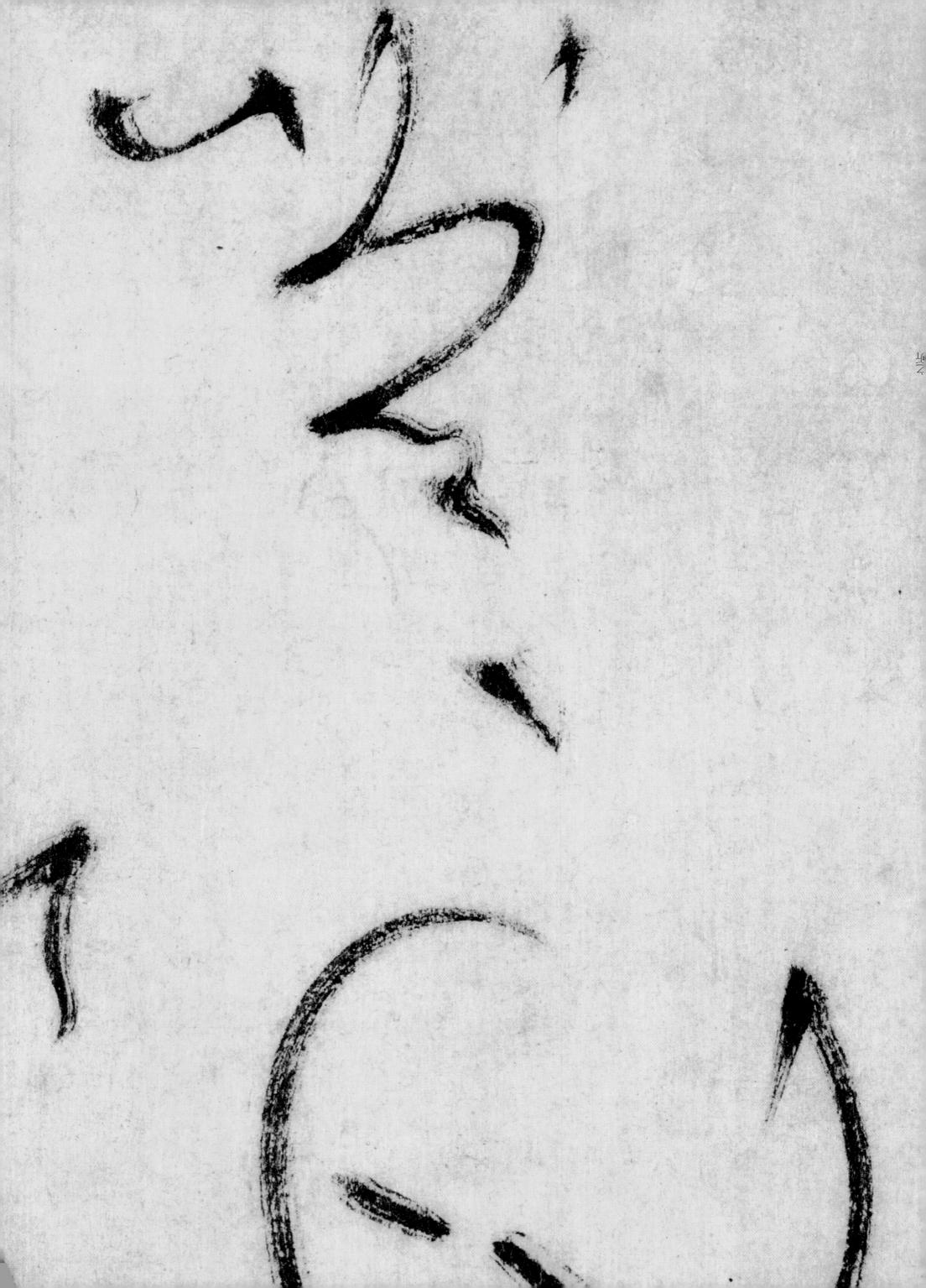

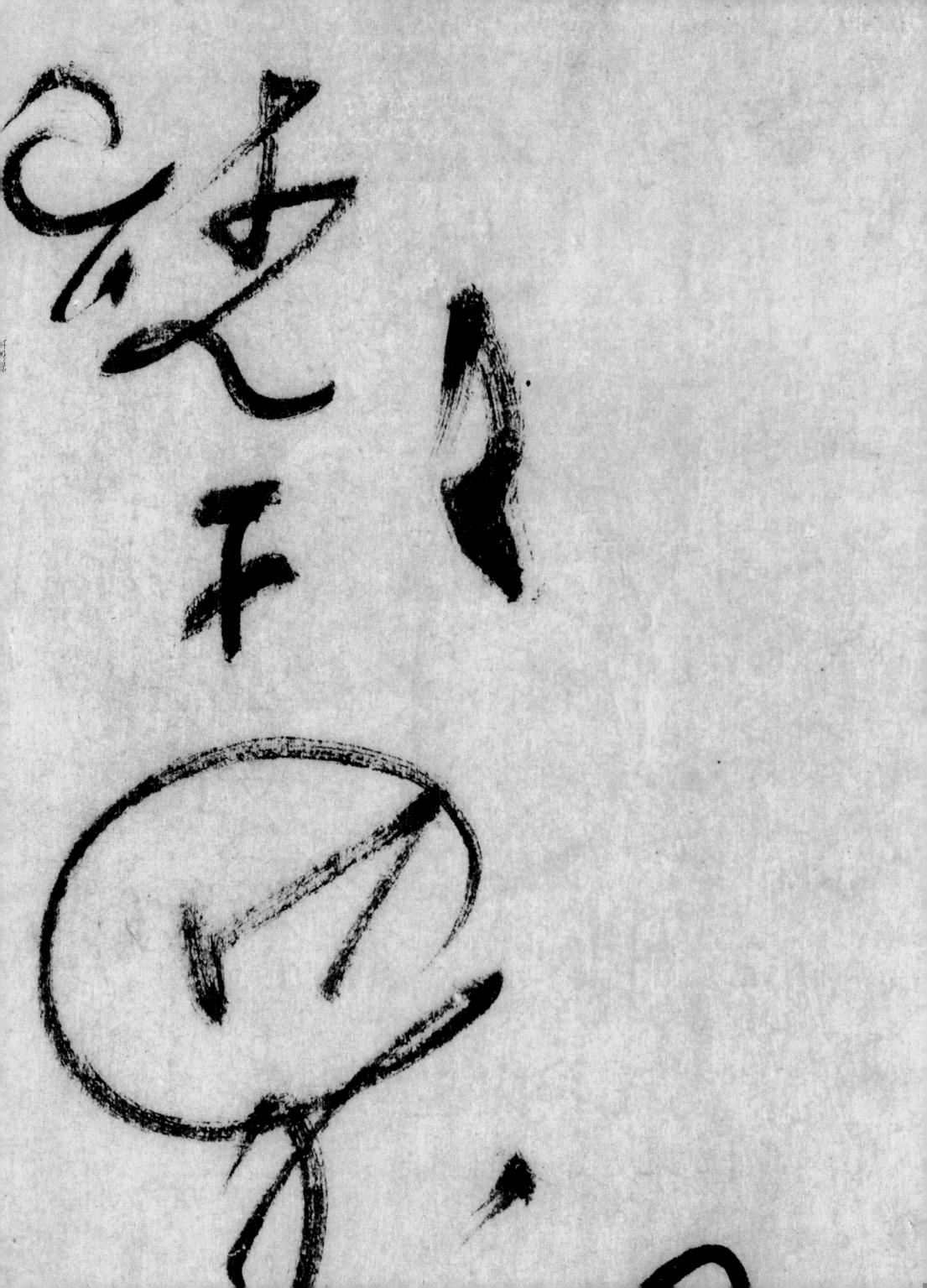

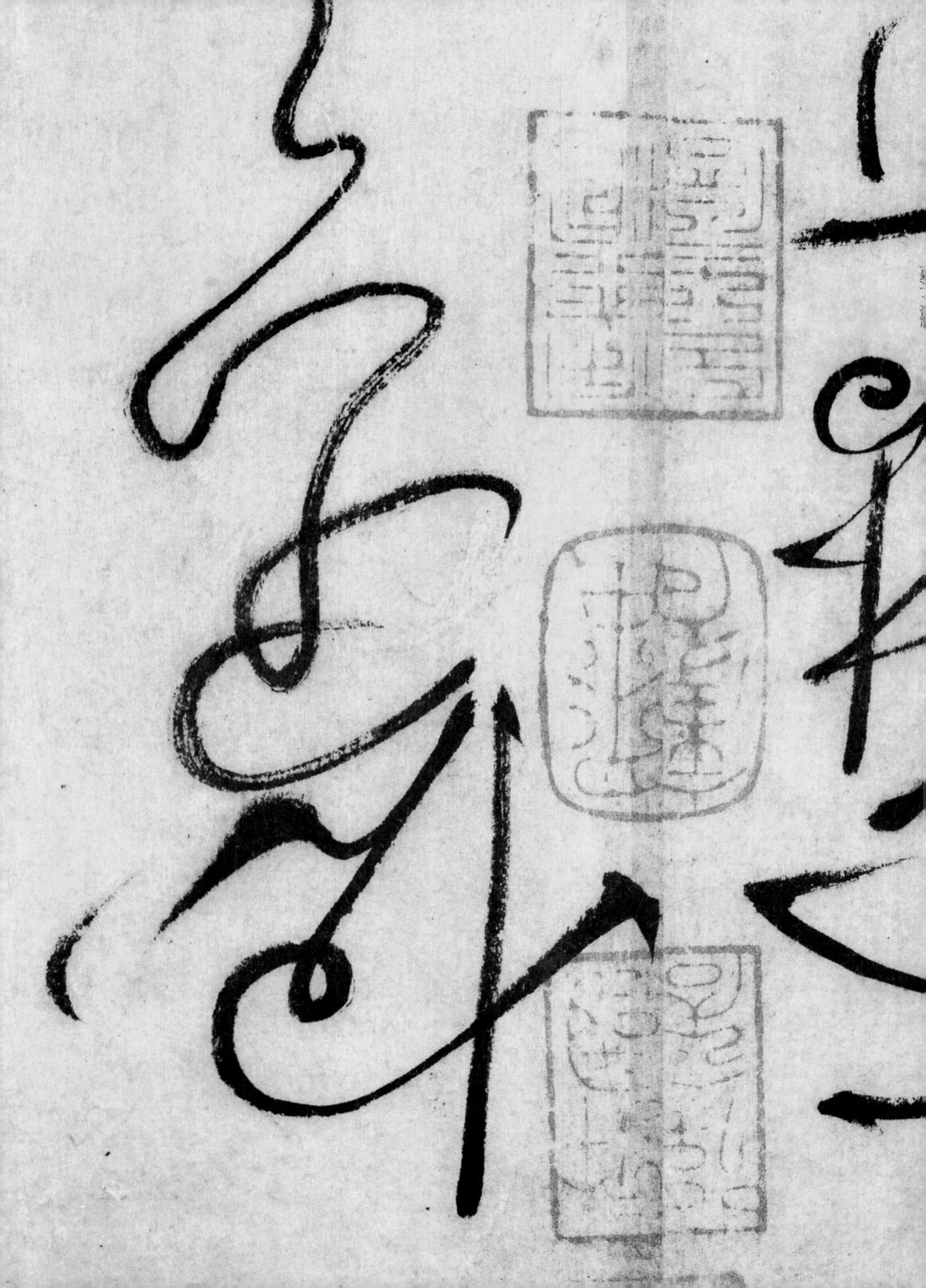

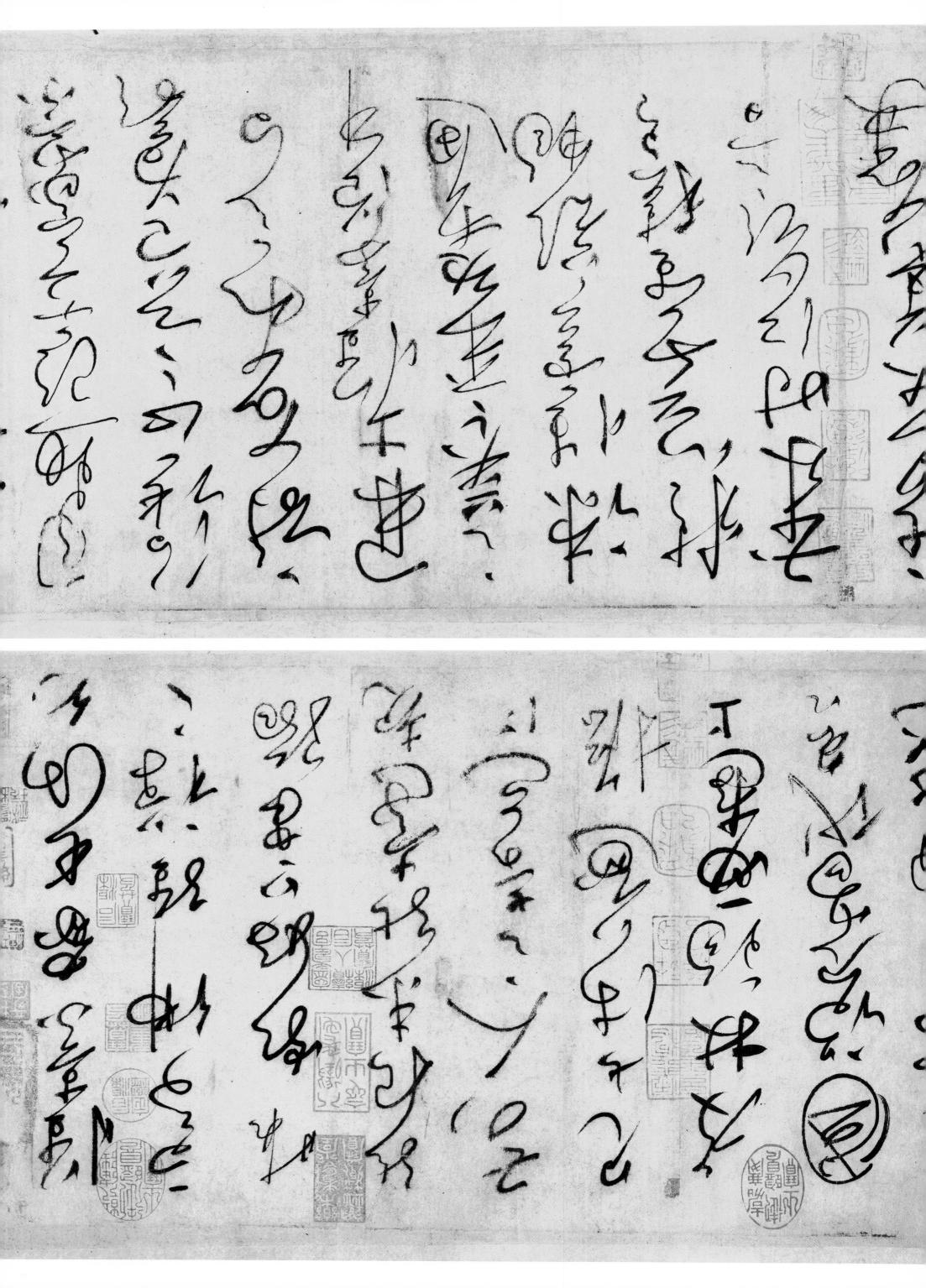

STATE OF THE STATE 100/140 100 TE Man Andrew State of States The Sold Star Garage Oce The The TAKE CO 1. (3): A A CONTRACTOR GRA DI

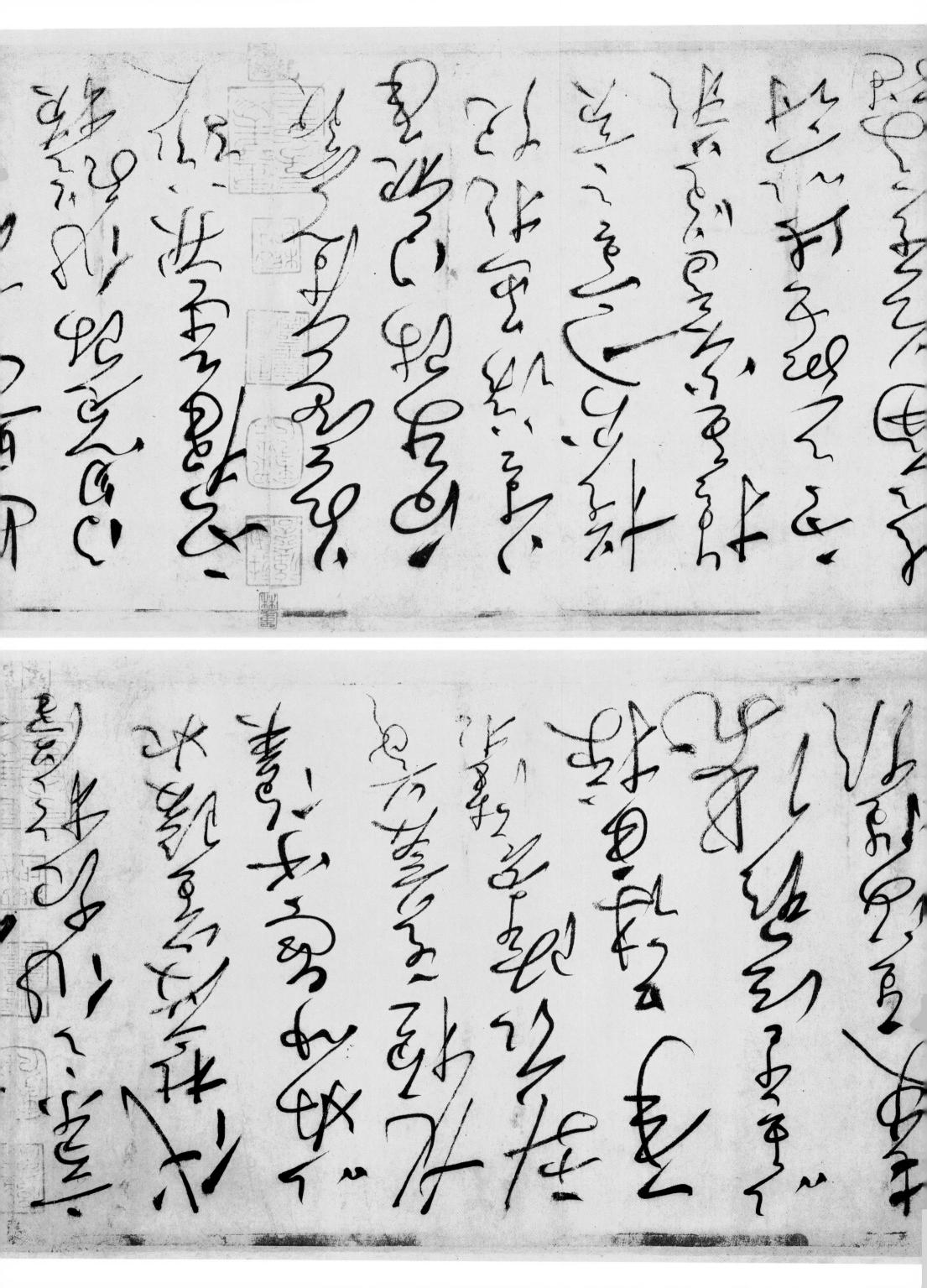

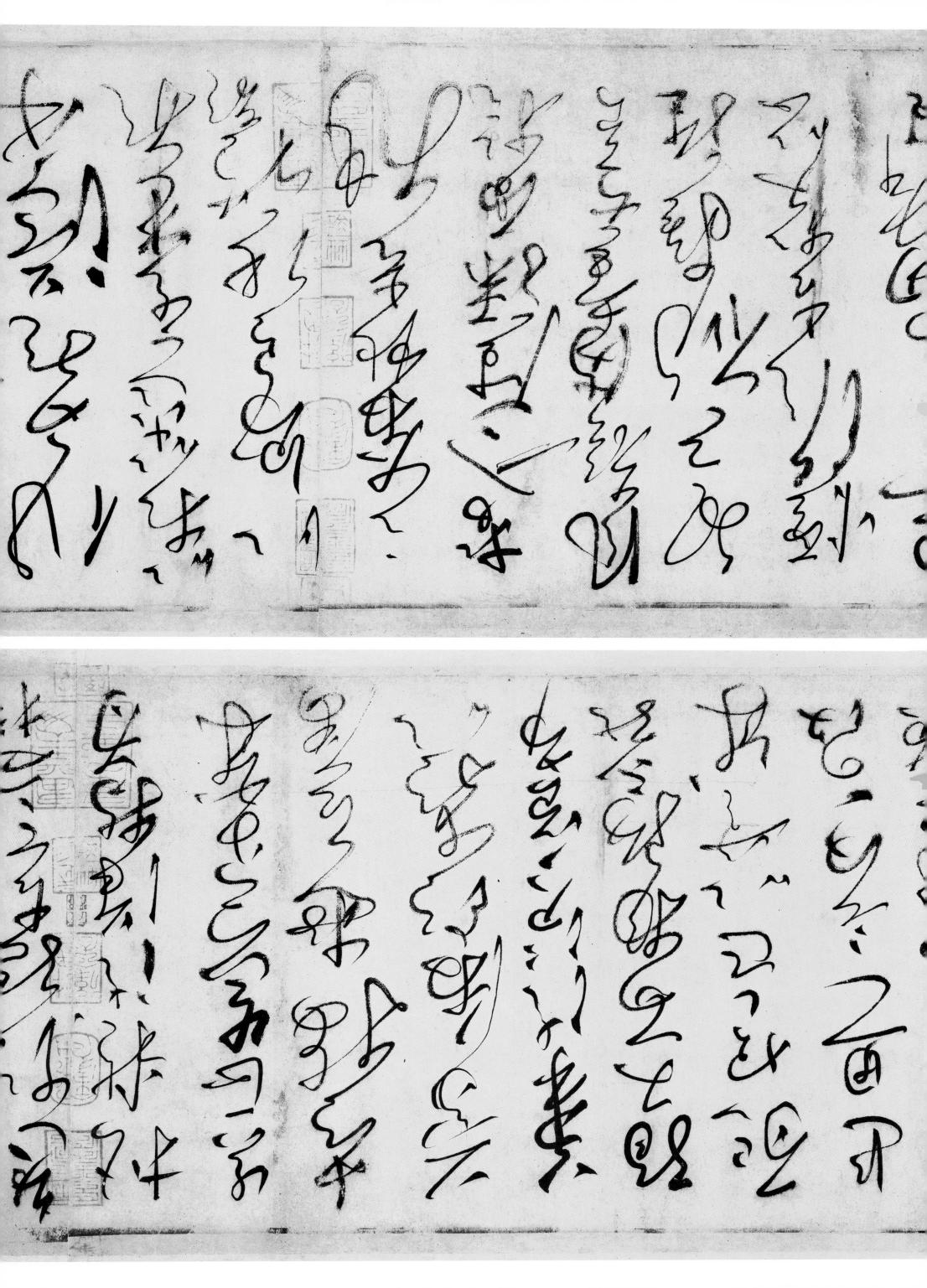

Day The total Mary Contraction BANK BY A CANA 公人 tale + 30 f

THE STATE OF THE S AN Sharman Chi Wall Stranger A STAME LE DE Wasser Jan John Broken る人を大きない。 to of the second るなする Ser Ser Ser 3 was the second with the second second

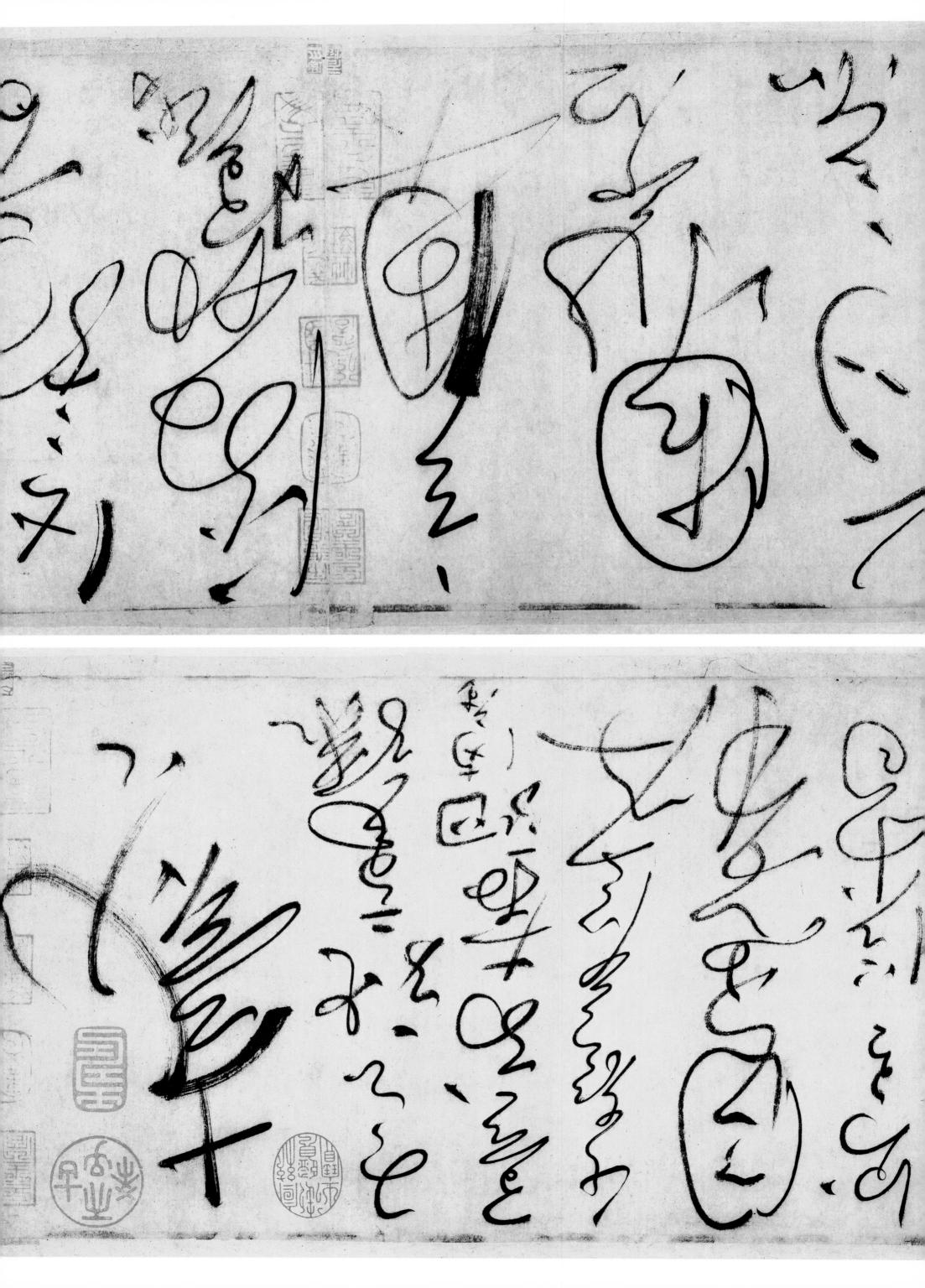